The Mindful Drawing Journal

The Mindful Drawing Journal

Your creative path to serenity

Mike Annesley

SIRIUS

For Anna

SIRIUS

This edition published in 2020 by Sirius Publishing, a division of
Arcturus Publishing Limited,
26/27 Bickels Yard, 151–153 Bermondsey Street,
London SE1 3HA

ISBN: 978-1-83940-924-0
AD007714US

Printed in China

Contents

'Believe you can and you're halfway there.'

Theodore Roosevelt

Introduction

Drawing and mindfulness make for a happy partnership. Mindfulness focuses on the direct experience of the senses. Drawing helps you concentrate on *looking*, and therefore is inherently mindful. At the same time, drawing is a form of *doing*, so your focus is actually double: you look and you take action, in a continuous rhythm of mental and physical activity. This takes you into the zone – where nothing impinges on your consciousness except the task in hand. That's the essence of mindfulness.

On mindfulness

Mindfulness is a way of living, a simple practical approach to daily existence that makes all its aspects more rewarding. In recent decades the idea has become familiar through mindfulness meditation courses, typically lasting eight weeks. Doing such a course can keep depression at bay in susceptible individuals. Stress and anxiety reduction is one of the proven benefits of mindfulness. The practice also tends to make you more confident, resilient and decisive, and better at concentrating and communicating; and it helps you overcome ingrained habits such as excessive drinking, smoking, eating or shopping. It opens the heart and mind – to the best that life, and other people, have to offer.

There's no need to do a course to benefit from mindfulness – although everyone should consider this option at some point. The beauty of mindfulness is that you can practise it at home, without expert tuition. The central principle is easily expressed:

You pay close attention, in the present moment, and without judging yourself, to your direct experiences.

It will be helpful now to break down this principle into its constituent parts, looking at each in turn.

Attention

The mind is an instrument, but also an inner landscape. Our thoughts wander within the mind, like clouds in a wind. When we turn our attention to a task, sometimes we get distracted by these floating thoughts, and follow them. But we don't have to do so. The mindful approach to random thoughts is to be aware of them but to let them go. If they are wrong, or trivial or irrelevant, there's no point in engaging with them. Instead, we do better to shift our focus back to our chosen activity – a process that will automatically displace these intruders.

The present moment

'Now', of course, is fluid: it surfs the wave of time. Even a quick drawing ends in a different moment from its beginning.

7

Nevertheless, you can choose to inhabit this fluid vehicle within time, and spend no time, as it were, thinking about the past or future. To be in the moment is to accept your unfolding experience – here and now. This is the heart of mindfulness. The practice is relaxing because it leaves no space for our regrets about the past and worries about the future – the two main components of anxiety. In the present, sitting down and drawing, say, a bowl of fruit, there's nothing to disturb your peace of mind.

Without judgment

Anybody engaged mindfully in an activity – whether meditating, sweeping leaves from the patio, or drawing – may be distracted at any time by thoughts or emotions crossing our minds unbidden. You might wonder if you forgot to lock the car, or start thinking for the umpteenth time about a difficult meeting tomorrow. The mindful approach is to let such thoughts go – to displace them with a consciously chosen focus of attention. At the same time, it's important not to judge yourself for having been distracted. Nobody can concentrate exclusively on a single task for long. Distraction is normal. Even when you're meditating, you needn't regard wandering thoughts as a sign of failure.

Mindful drawing – and valuing your creativity

So: drawing grounds us in the present moment, takes us into the zone. This is the easy part. What some may find more difficult is to draw freely without judging the quality of the image, especially if they regard themselves as lacking artistic skill or training.

Here's a further key principle, just as important as the mindfulness principle highlighted above:

While mindfully drawing you express yourself freely, without giving any thought to such matters as accuracy, perspective, neatness or artistic quality.

In other words, let go of all preconceptions about what drawing is, and stop yourself from making irrelevant quality judgments about your work. The messier, the better. Fill your pages with the raw, untidy energy of self-expression.

How to use this book

This book is intended to be used in various ways: as a mindfulness course with a combined emphasis on practicality and imagination; as a guided sketchbook for regular or occasional use; as a tool of mindful self-discovery; as a visual journal of personal growth. All these functions overlap; and, in any case, once you make a start on these guided drawings, you're sure to find them valuable in your own way.

We have no wish to be too prescriptive: our main purpose is to prompt and inspire. Hence, we're giving here not a set of instructions for use but, instead, a handful of suggestions you might or might not wish to follow, with plenty of choices for the individual:

o Either work through the book from beginning to end, or chart your own course, prioritizing what attracts or interests you. Or just open the book at random and see whether the prompts on those pages stimulate your creativity.

o After completing a drawing, use it as the basis for a meditation. Sit still and upright, relax your mind, and focus on your breathing. Then let the image fill your mind. Explore its details, its symbolic implications and any emotions it invokes in you. If you find your attention wandering, bring it back, in the present moment, without judging yourself.

o Some ideas are given for 'Contemplation' at the end of some of the drawing suggestions. By all means think up your own contemplation strategies, along similar lines. Do this for any drawing that seems to lend itself to reflective self-analysis. In

practice there's no difference between contemplation and meditation – except that the latter is more narrowly focused.

○ Consider getting into the habit of doing new drawings over old, in a different colour. Or just use any free space within your existing drawings. Filling your drawing journal with marks, leaving a minimum of blank spaces, expresses the fullness and complexity of personality. However, sparseness may seem more appealing to you. It's a matter of personal choice.

○ Use the journal spaces in this book to write down any productive thoughts you had while doing your drawings, or any reflections you had on contemplating the finished result. Identify issues and challenges and set goals for yourself. Don't be too rigid about the use of space: feel free to add little drawings to your journal entries, and words to your drawings.

Happy mindful drawing and journalling!

1

Making Mindful Marks

Drawing without limits

Before you do your first drawing, spend a mindful five minutes handling this book and your pencil, focusing on look and feel – and nothing else. Identify with your equipment: for now, you are your tools. Then get started with a wild scrawl of freestyle self-expression. When you progress to the particular subjects suggested, don't worry how well you represent them. Self-expression is the aim, uninhibited by any preconceptions about artistic quality.

'I sometimes think there is nothing so delightful as drawing.'
Vincent van Gogh

Wild and free

'To dare is to lose
one's footing momentarily.
To not dare is to
lose oneself.'

Søren Kierkegaard

Let go of preconceptions and rules and just make some senseless scribbles. Set a timer and allow yourself one minute to put random abstract markings on the page as fast as you can. Imagine it's your unconscious reminding you of its energy. Scribble over the margins if you wish. Individualize your book with this first drawing, like a graffiti artist given licence to personalize a wall.

Kite-flying

Your thoughts are like clouds, floating through consciousness. Draw them like this, crossing the page. Keep adding extra clouds here and there to make a cloudscape. Then add a kite: this is your conscious will, a tool of deliberate exploration amid the mind's random wanderings. Put yourself at the foot of the drawing, steering the kite on a cord with little flags attached.

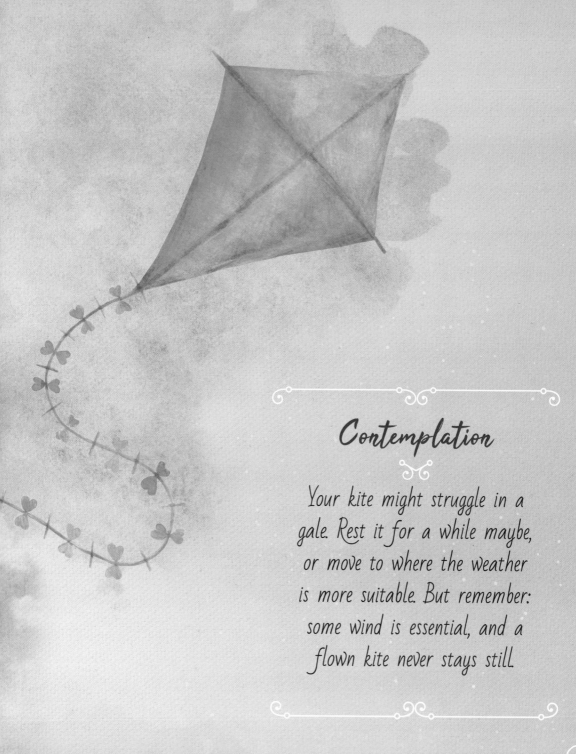

Contemplation

Your kite might struggle in a
gale. Rest it for a while maybe,
or move to where the weather
is more suitable. But remember:
some wind is essential, and a
flown kite never stays still

Drawing 3
Out of place

This project stretches the imagination. Choose an item from the list and draw a picture of it in an unexpected setting. For example, if you choose a hammer, you could show someone nailing a new duckpond in place in a desert. Be surreal. Build in contrasts of scale. Include any incongruous details you can think of.

- **Item of furniture** – such as a chair or a wardrobe
- **Animal** – such as a swan or an elephant
- **Mode of transport** – such as a boat or a bicycle
- **Tool or device** – such as a hammer or a telescope
- **Musical instrument** – such as a harp or a saxophone
- **Tableware** – such as chopsticks or a soup bowl

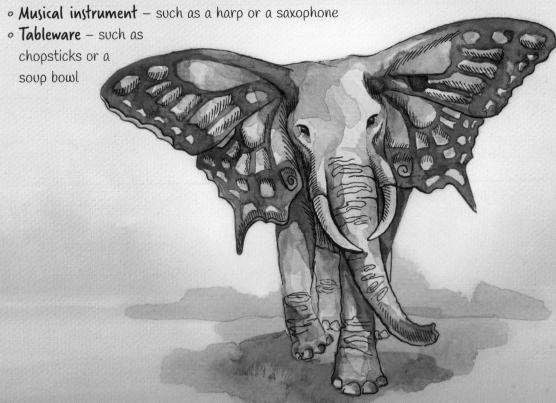

Contemplation

Is there something about your object that carries a lesson for your life?
For example, a napkin might suggest you should think about self-protection,
or a boat that you should consider making an inner journey or
reaching out from your comfort zone.

Drawing 4
Life in the jungle

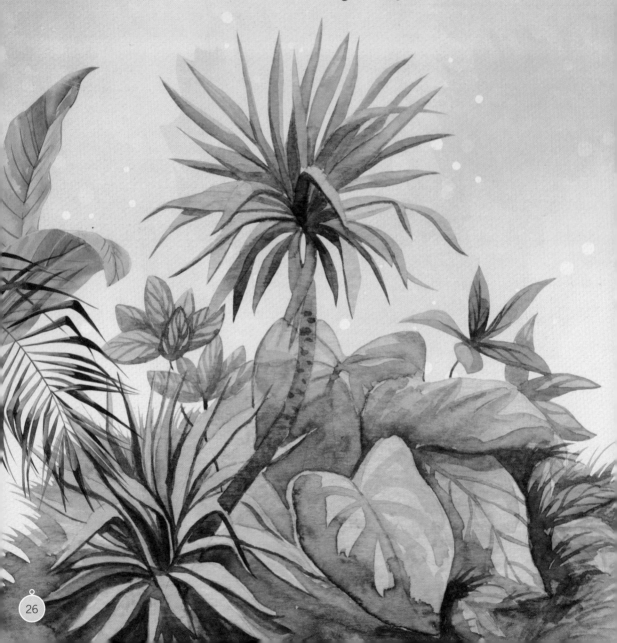

'Those who dwell among the beauties and mysteries of the earth are never alone or weary of life.'

Rachel Carson

The following pages show a stylized outline drawing of a jungle. Trace a stronger outline over some of the leaves and add any animals you think might inhabit this imaginary place – such as lions, tigers, crocodiles, birds, monkeys, snakes, lizards, butterflies or spiders. Draw just the parts that show, the rest being hidden by leaves, trunks or other features. Add in more vegetation with a green pencil if you wish. And include features of your own, such as a river, waterfall, rocks or a view of mountains behind.

Drawing 5
Free pages – Anything goes

Use these pages for any experimental or imaginary drawing you might wish to do. Go wherever your ideas take you. If you wish, you can incorporate human figures or faces in a highly simplified style. Five possible themes are listed below, to inspire your sketching.

- Acrobats
- Fashion show
- Utopia
- Adventure
- Play

2

Pencil in the Present

Being here now

As you sit with this book, ready to draw, it's good to spend a few minutes focusing on your sensations – and nothing else. You might notice the pressure from the chair, or the sounds of your breathing or distant traffic. Let any thoughts just pass out of your mind as you return your focus to these experiences. Just before you put pencil to paper, think of the drawing you'll do as a space ship that takes the moment voyaging through space-time.

'What we call "I"
is just a swinging door,
which moves when we inhale
and when we exhale.'

Shunryu Suzuki

Rings around now

There's a universal symbol for mindfulness: a falling droplet of direct experience – our sensations or emotions – hitting the surface of calm water and sending out ripples. The ripples are the inner consequences of direct experience, particularly the thought-chains that spin off from the moment. Draw this idea, not as a stylized droplet but as something specific and detailed. Some inspirations could be:

o Rainwater dripping into a barrel
o Fish breaking the surface of some water from below
o Sound waves from a loud noise
o Scattering of fragments from something dropped and broken

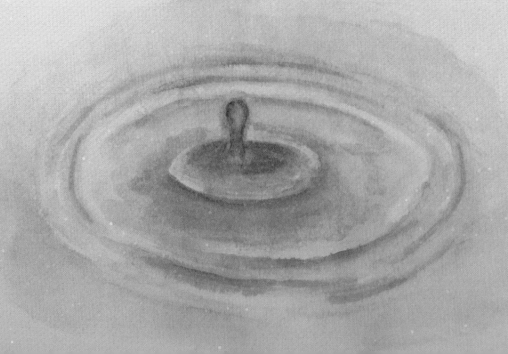

Still-life with shadows

The aim here is not detailed accuracy, only a well-observed visual impression. Arrange various kinds of fruit in a bowl and set up an angled desk lamp to create light and shade. Copy the outlines you see and fill in the shadows with parallel hatched lines, or with a softer pencil; leave highlights white. Don't worry about volume or perspective.

'There are only ten minutes in the life of a pear when it is perfect to eat.'

Ralph Waldo Emerson

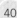

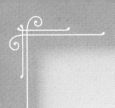

Contemplation

You've caught a moment, in black
(or whatever colour you used) and white
— within your colourful world of change.
Alter the lighting and compare your
drawing with the way the fruit bowl
looks now. With arrows and handwritten
labels, annotate the changes you observe.
You've seen your still-life for what it is:
something momentary and transient.

Catching your breath

This is an exercise in pure self-expression. To focus on your breathing is a core mindfulness practice — an easy way to connect with the now. Relax, empty your mind of thoughts and rest your attention on your in-breaths and out-breaths. Take up a coloured pencil, close your eyes, and draw anywhere on the page, up and down in rolling waves or scrolls, as if directly connected with your breathing. Don't lift the pencil: let it travel fluidly. Stop after a while, change colours and let the new waves overlap with the old. Continue, using as many colours as you like.

'When you are breathing, and know that you are breathing, that is mindfulness of breathing.'

Soren Gordhamer

Drawing 9
Your mindful body

The idea here is to draw a "body scan" — a complete picture of how you experience your body in the present moment — by resting your attention on each part of your body in turn, noticing the sensations and rendering them with your pencil.

First, draw a simplified outline of your body. It can be seated (as you are now) or floating in space. Then fill in details to represent the parts you can see (without moving) or in which you feel sensation.

'The whole soul in
the whole body, in the
bones and in the veins
and in the heart ...'

Giordano Bruno

Drawing 10
From A to B

This is an exercise in mindful imagination. On pages 54–5 are a starting point (home) and an endpoint (temple). Draw or map the terrain between these two locations, and then draw any striking aspects of a meandering journey you take in your mind between them. Put in some obstacles and the ways you get around them. Make your drawing as pictorial or as abstract as you wish.

Some suggested
features are:

○ Labyrinth
○ River
○ City
○ Outer space

Free pages – Happenings

Use these pages to reflect any momentary experience affecting you. It could be something you remember or anticipate, or something you imagine. Some possible ideas are given below:

- Surprises
- Contrasts
- Conflicts
- Successes

It is more gratifying to relish surprises than to prepare for every eventuality.

3

Me Time

'There are things I can't force. I must adjust. There are times when the greatest change needed is a change of my viewpoint.'

Denis Diderot

The blossoming self

The key to happiness is to replace negative thinking and bad habits with positive thought and behaviour, regardless of what ups and downs life brings your way. This is personal growth, the inner flourishing of the true you. Drawing offers a wonderful way to chart your changing goals, challenges, successes and disappointments, and the discoveries you make along the way.

Hot-air ballooning

Thoughts are like hot-air balloons floating across your mental sky. Many will be unwelcome or unhealthy, but you can just let these drift away. What you mustn't do is engage in battle with them, as that will encourage them to hang around longer. On the following pages, draw your current preoccupations as a fleet of hot-air balloons to give yourself a snapshot of your inner life. Some will be worry balloons.

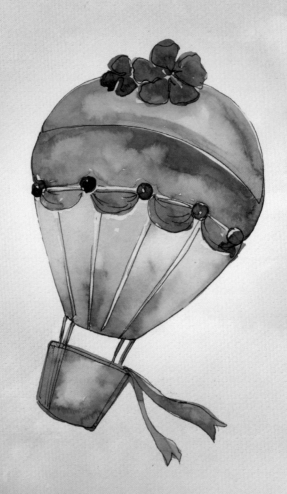

Specific suggestions are:

○ Draw clouds in the upper part of the page and mountains on the right side — you want to make your worry balloons clear the highest peaks by lightening their loads

○ Let each balloon you draw represent a challenge or situation in your life. Draw any other people involved in the basket, along with symbolic elements. You can dangle large items — such as a house or a work in-tray — from the basket on a rope, and alter the scale accordingly

○ Size the balloons according to their proportionate importance to you

Contemplation

Look at your hot-air snapshot and consider what you need to jettison from the baskets to make the balloons rise higher and drift away — maybe you need to reduce your commitments, or stop catastrophizing, or resolve tensions by reaching out to someone.

Drawing 13

Snakes and ladders

Snakes and ladders is an ancient Indian board game, representing the interplay of good and bad outcomes – snakes are slides of bad luck or vices, ladders are uplifts of good luck or virtues. Follow Indian practice by drawing the best things in your life at the top of the board on the next pages and the worst at the bottom. Then draw snakes as you remember or imagine your challenges, and ladders as you imagine yourself climbing out of them.

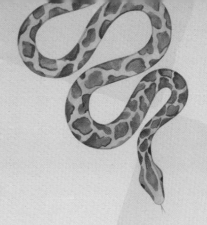

- Each snake could be a challenge, a temptation, a difficult person, or a personal weakness you need to correct

- Each ladder could be an opportunity, a resolution, an ally, or personal strength

- Draw all around the board, and end with the triumph of good over bad, in the top-right corner

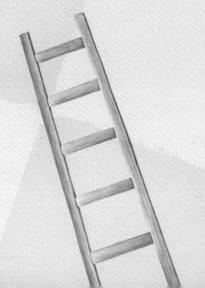

Drawing 14

Keynote speaker

This drawing is all about confidence — being proud of who you are and happy
to project yourself to the world at large. Imagine you're on a platform in a huge
auditorium, with a giant screen behind you, mirrored by a screen in front of you.
Draw the interior of the hall as you see it and the ranks of tiered seating. Draw
those individuals you particularly want to see and who accept you as you are, in
front-row seats. Include supportive loved ones as well. On the screen show aspects
of yourself that define you, including your best values.

'No one can make you feel
inferior without your consent.'
Eleanor Roosevelt

Contemplation

Imagine the speech you'd make about yourself — what you want to achieve, what your priorities are and how you'll go about meeting them. Make notes for your script in the journalling space. Imagine delivering your speech and hearing the auditorium fill with rapturous applause.

Dreamwork

Our dreams can reveal our deepest preoccupations – the ones we don't even acknowledge to ourselves. If you have a vivid dream, draw it as a way to tease out its possible meanings. Use coloured pencils if it was a colourful experience. You'll probably end up with a surreal image, with a strange energy. Don't worry if you have difficulty rendering faces – simplify to a few stylized marks. Present scenes through time in a cartoon-like sequence.

Contemplation

Ponder possible meanings of what you've drawn. Look for archetypes – such as the old man or woman, the trickster (joker), the divine child. These may represent aspects of yourself, as described by Carl Jung. If there's action in your dream, ask yourself whether your unconscious is urging you to follow that path or keep well away: flying may be urging you to follow your destiny or beware of a fall

Mindful memory

Memories are the archive of the self, a precious part of who we are. Mindful activities can sharpen the brain and enhance memory power. They exclude irrelevant thoughts and recollections that can fog the memorizing process. On the following pages are two self-testing drawing projects designed to assess and stretch the visual memory. After a week or so, try again, on a separate sheet of paper, and compare the result with your first drawing. Can you see an improvement?

Drawing 16
Cold memory

Open your fridge door and spend two minutes memorizing what you see and how things look — including the names on any labels visible. Spend ten minutes at your drawing table meditating — on your breathing maybe, or on hands. Then do a drawing of what you remember seeing in your fridge. Compare it with reality. Give yourself a mark for your performance (if you like, you can count the items on first inspection, and use that number for marking).

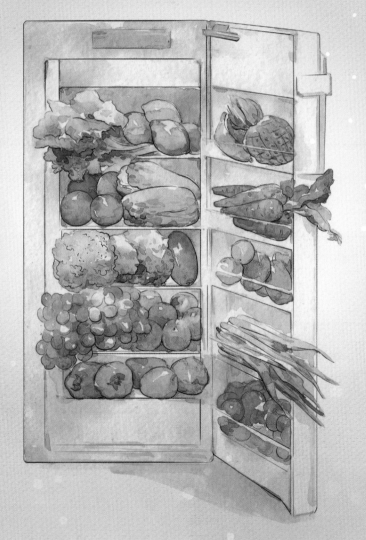

Street views

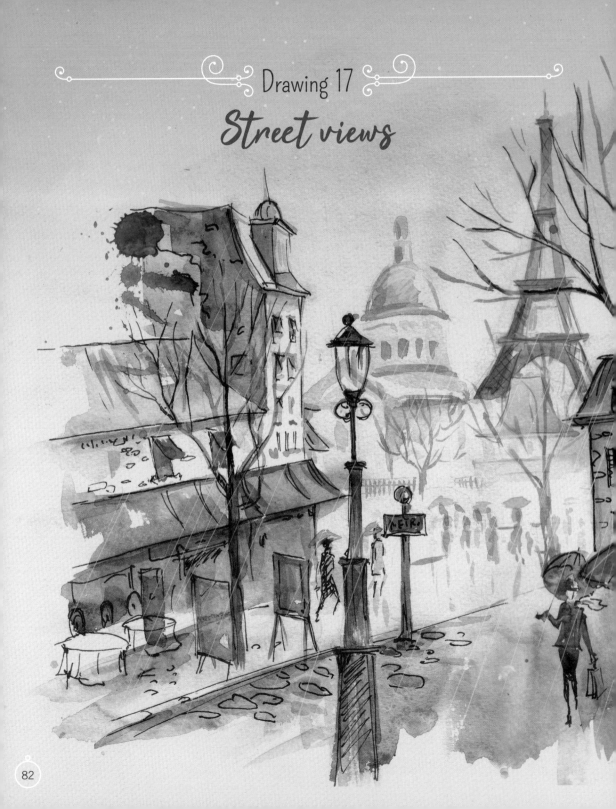

First, take a walk up and down your local shopping street, looking mindfully at the frontages and committing them to memory—not names necessarily but types. Look at upper stories and roofs as well as at ground level. Then go home and draw both sides of the street, in two friezes, one above the other. Add the names if you remember them, and draw the contents of store windows, at least symbolically. Photograph your drawing and give yourself a score for your observation skills next time you visit.

Free pages — Possibilities

Use these pages to draw the way you'd like
to be and live, and the opportunities you
might take to get to that ideal.
Some possible themes are:

- Vocation
- Family
- Creativity
- Lifestyle

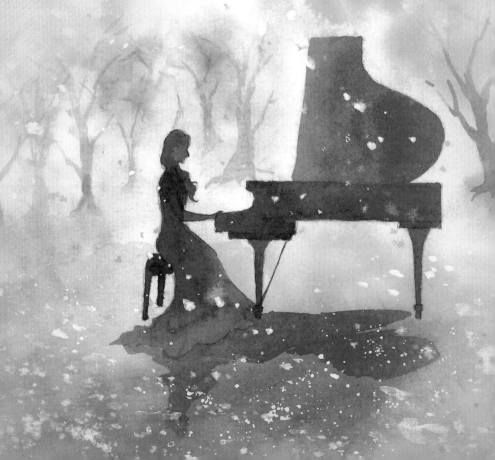

4

Toward Inner Peace

'Nobody can bring you peace but yourself.'

Ralph Waldo Emerson

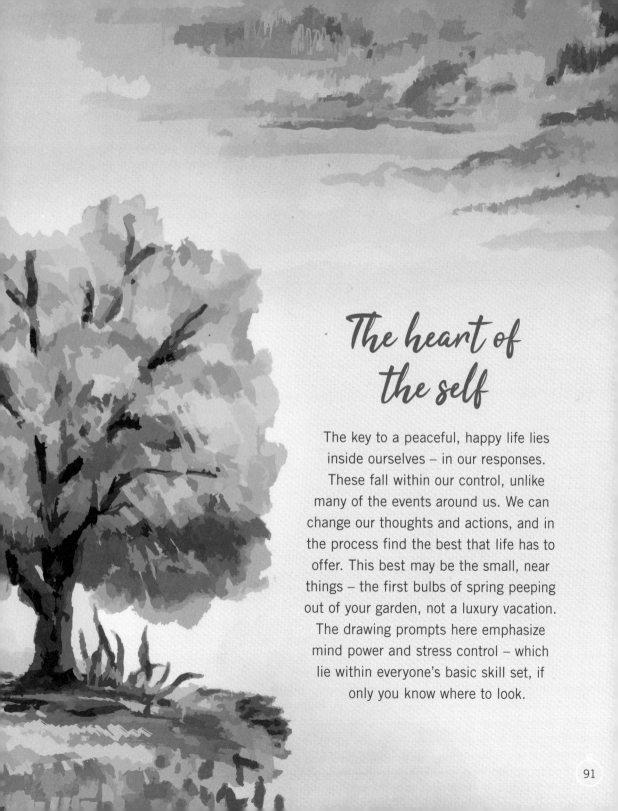

The heart of the self

The key to a peaceful, happy life lies inside ourselves – in our responses. These fall within our control, unlike many of the events around us. We can change our thoughts and actions, and in the process find the best that life has to offer. This best may be the small, near things – the first bulbs of spring peeping out of your garden, not a luxury vacation. The drawing prompts here emphasize mind power and stress control – which lie within everyone's basic skill set, if only you know where to look.

Your safe haven

As preparation, sit and focus mindfully on your breathing to relax you and still your thoughts. Then conjure in your imagination or memory anywhere that would be a peaceful place to be right now. Draw the view you'd find it restful to contemplate, under a sky with clouds and maybe a rainbow. This is where you can go, in your mind, to be deeply soothed, protected from stress, content with who you are.

Contemplation

Meditate on your drawing, using it as a cue to replicate in your mind the scene you've pictured. See your internal issues, and your emotions, as the weather here — observe passing clouds without involvement and without judgement, secure in yourself. Feel the haven's healing energy entering your being — part of your life's permanent inner toolkit.

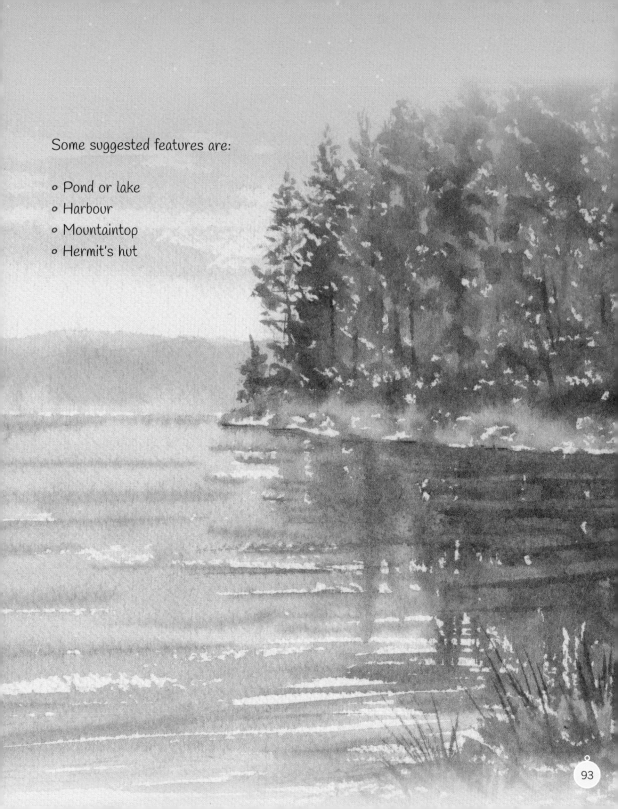

Some suggested features are:

- Pond or lake
- Harbour
- Mountaintop
- Hermit's hut

93

Drawing 20

Frieze framing

The repeated elements in a frieze can give your creativity a rhythm that is deeply soothing — like swinging your legs when walking or cycling. Imagine you're a designer trying out wallpaper or sculpted frieze designs for a grand house. Either do it carefully, within ruled lines, or freestyle. Don't worry if you're repetitions aren't exact: variety is life-affirming! Some ideas for motifs are:

- Pine cones, flowers (for the conservatory)
- Teddy bears, dolls, toys (for the nursery)
- Fruit, vegetables, fish (for the dining room)
- Palm trees, sunrises, birds (for the living room)

Pattern-making, reflecting
a deep wish to make sense
of our world, is an effective
and mindful way to bring
calm to our inner being.

Drawing 21
A leaf mosaic

Leaf sweeping has Zen overtones: in the real world it's mindfulness in action – so long as you focus on the task and let unwanted thoughts drift away as soon as you're aware of them. Here, in the imagined world, is the opposite side of the coin: leaf accumulation. Fill the following pages with a pattern of autumn leaves of different shapes and sizes, all overlapping. Use shading to give them a range of tonal values. If you wish, use a tree guide as a source for actual leaf shapes.

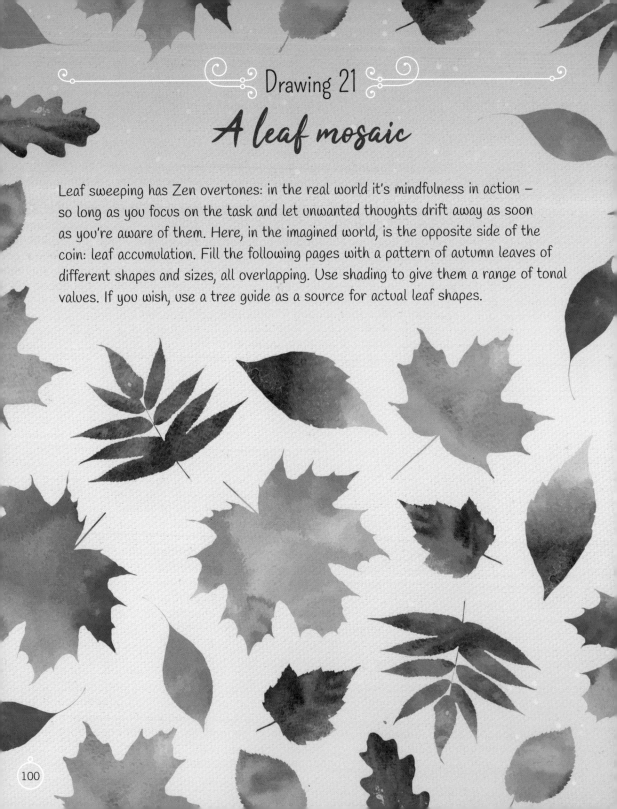

'The practice of
Zen is forgetting the
self in the act of uniting
with something.'

Koun Yamada

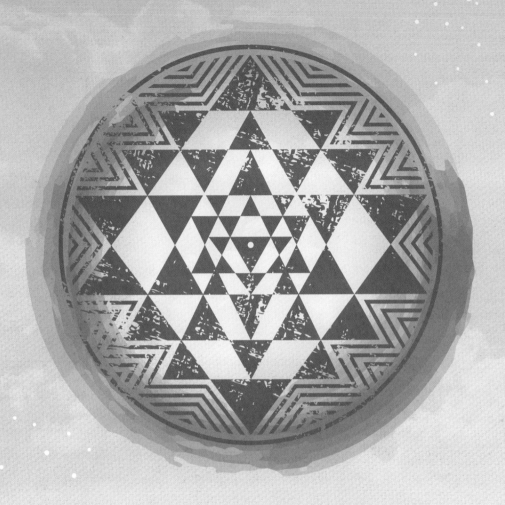

Mandalas and meditation

Mandalas are specially devised images used as a traditional focus for meditation – especially in Buddhism. Originally they were symbolic representations of the cosmos, depicting deities in their "palace of the gods". Hindu practice favoured a more abstract design, especially interlocking triangles within a lotus petal frame (the sri yantra). Drawing your own mandala for meditation is one of the most rewarding ways to enlist art in the service of self-exploration and inner healing.

Make your own mandala

Using a pair of compasses or the base of a can or similar, draw a generously sized circle. Place a dot at the circle's centre – this is traditionally known as the **bindu**. Fill the inner space with a symbolic or geometric design. Finally, create a set of concentric frames around the circle using a ruler for straight lines. Some suggestions for the details are:

- Lotus leaves
- Interlocking triangles
- The tai chi (yin yang) symbol
- Seated Buddha or meditating figure in the lotus position
- Pine trees, symbolizing longevity
- Sun and star motifs

Contemplation

Meditate on your mandala once it's complete. Prepare by emptying your mind and focusing on your breathing. Then, run your gaze over the design, starting with the outer frame and working inward. Contemplate the symbolism: if your design is abstract, think of it as expressing the mystery of existence, or the union of physical and spiritual selves. Imagine the healing energy of the mandala entering your body and suffusing your heart. Finally, meditate on the central bindu: the portal to pure being.

Drawing 23
Theatre-going

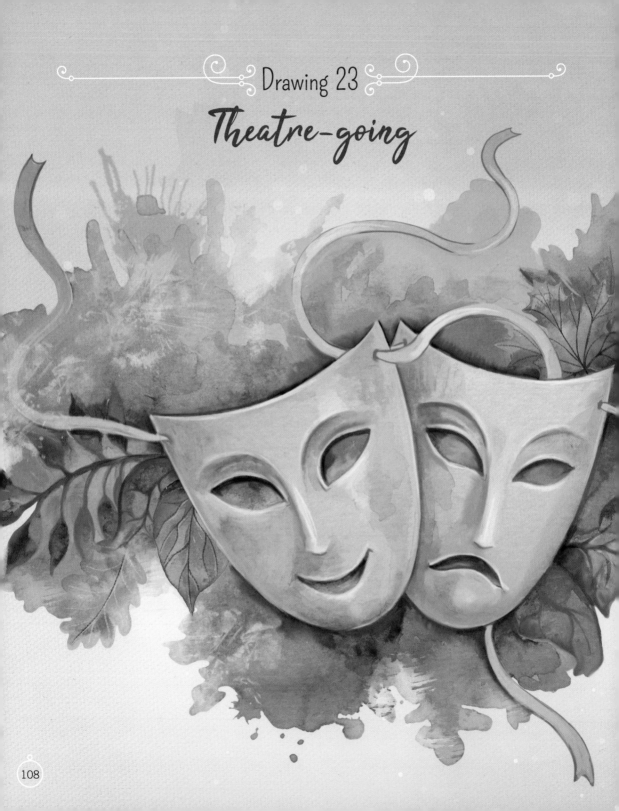

Some challenging situations in
life are best dealt with by detaching
yourself — being a passive observer of
others' emotions, like a spectator of theatre.
Draw a stage with suggestions of scenery and
side-curtains, as seen from the stalls. If you like,
show the backs of heads to indicate other audience
members. Finally, depict a difficult situation on the
stage itself: perhaps a family drama, or a tricky
moment at work. What seems intimidating in
real life may lose its power to upset you
when viewed in this light.

Free pages – Visual affirmations

Use these pages to picture any anxiety or stress in your life and any antidotes you can identify. Some possible approaches are:

o Yourself in armour or in a shelter, protected against battle or storm
o Stress or pressure as a creature, which you shrink or cage by mind power
o Change outside, stability inside
o Resilience as a tree, resisting any weather

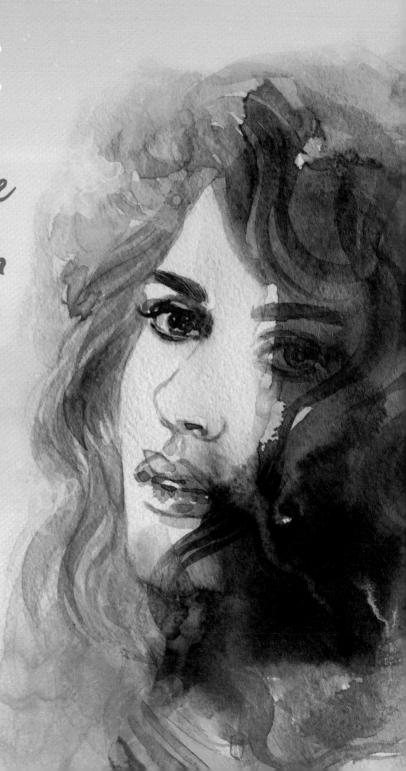

5

People
Power

"What wisdom can
you find that is greater
than kindness?"

Jean-Jacques Rousseau

When drawing gets personal

If you're interested in drawing faces, just attend mindfully to what you see and forgive yourself for not being Rembrandt. You will always be able to suggest a likeness in drawing, even if you can't exactly capture one. Simplify as much as you like. In a portrait, the body language, clothes, and hairstyle, are often the keynotes of individuality. Portraiture, in any case, is not the only way to represent your feelings for people as you'll discover: you can do it, for example, by drawing gifts or using symbolism.

Drawing 25
A self-portrait

Mindful self-acceptance is a necessary foundation for happiness. What better way to lay the first stone than with a self-portrait? Look at yourself in a mirror, as if taking an honesty exam: this is no time for self-flattery. Draw what you see. If you end up with a caricature, through lack of art training, that's no problem! By all means include humorous details, if you like, such as showing yourself in scruffy, torn clothing. However, treat the project seriously and sincerely as an acceptance of who you are—a rejection of self-delusion.

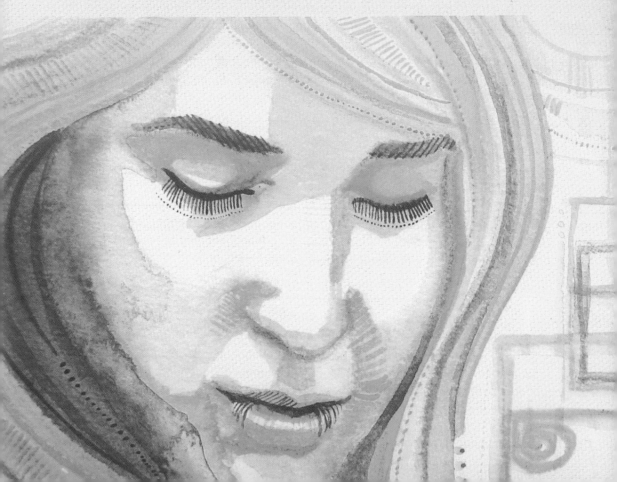

Contemplation

Consider the relationship between your self-portrait and you. The drawing is merely a marker for your true self. But then so is your reflection in the mirror and the face other people see. You can't change your face, but you can do a lot to change your habitual responses—for the better!

The radiant heart

The heart is the radiant origin of love and compassion, and like the sun sends healing gifts in all directions—an endless, all-powerful transmitter of benevolent energy. Celebrate and extend your power of giving by picturing your heart as an energy source, using one of the prompts given below. Then use your drawing as the basis for a loving kindness meditation (*see* the Contemplation on page 125).

- Draw your heart within your body, as a sun or pump or other energy source. Show, either symbolically or literally, the people you choose to receive your love—maybe in concentric rows around the body. Draw waves of energy radiating out to them

- Alternatively, draw the heart as a windmill or other power source. The background can be either your body or a symbolic landscape

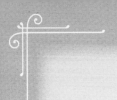

Contemplation

As you meditate on your drawing, imagine waves of love coming off the page into your heart—self-love, a forgiving acceptance of yourself, is the basis of outgoing love. Then imagine these waves reaching your partner, best friends, family, work colleagues, neighbors, and everyone you know—even people you dislike. Accept, forgive, love. This is the loving kindness meditation, a staple of mindfulness practice. You can write down your thoughts about the experience here.

Drawing 27
Warm patterns

Knitting has become cool again these days. Exercise the pattern-making part of your brain by devising some symmetrical sweater designs within the outlines given as gifts for those dear to you. Restricting yourself to black and white is fine: traditional Icelandic sweaters are made from undyed wool from black and white sheep; grey and brown are also natural. But use colors too if you wish. Some ideas for motifs are:

- Abstract geometry
- Stylized pine trees and cones
- Stylized fish, whales, and sharks
- Stylized reindeer and/or birds

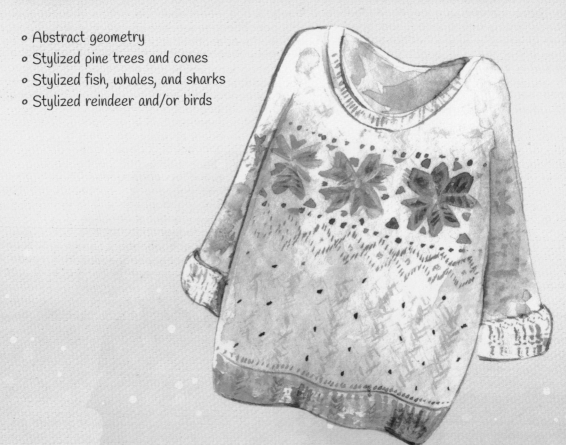

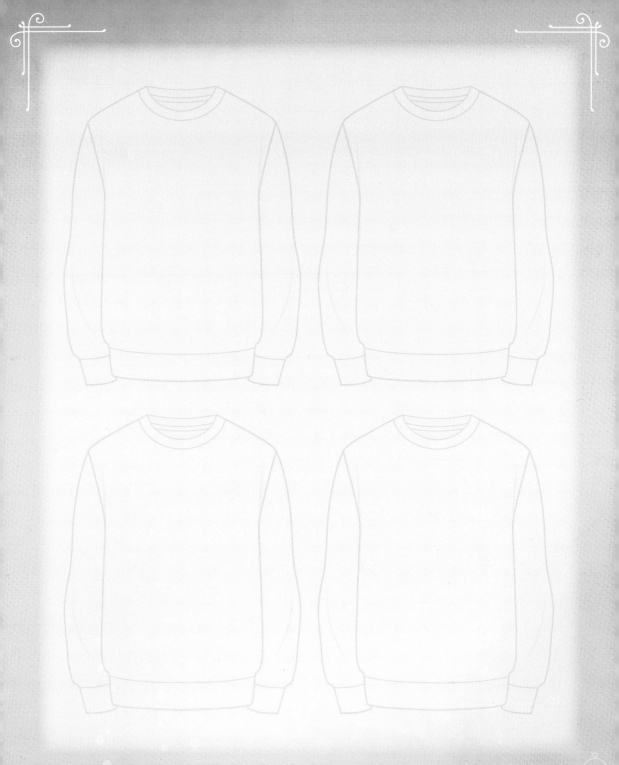

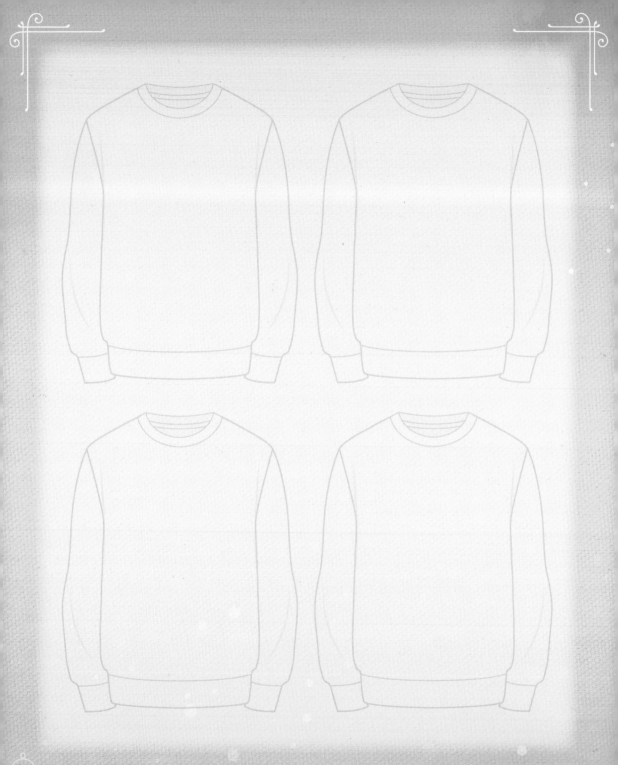

Contemplation

Imagine giving each sweater to your chosen loved one—the gift of comfort is precious, so this will be a heart-warming moment. Think of the person putting on the sweater and spinning around to show you how it looks. Give them a loving hug in your imagination.

Bridge-building

Mindful communication is a vital part of a loving relationship but can so easily break down—owing to complacency, misplaced priorities, distraction, or just carelessness. If you seek to repair a rift, draw the person and the chasm between you, then draw the bridge that will connect you again. Invest this drawing with your commitment to reach out with love. The bridge can be as elaborate as you like—anything from a rope bridge to an elaborate suspension bridge.

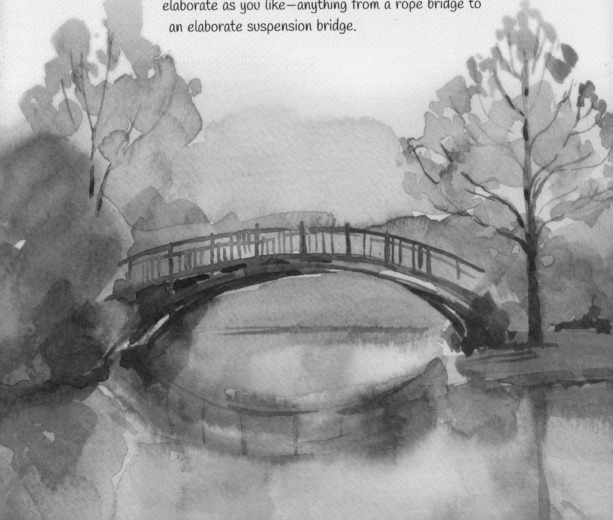

Contemplation

Ask yourself what you need to do to start bridge-building for real. Will this require a leap of faith, or some elaborate engineering? Make a promise to yourself and make it happen, whatever the difficulties.

Love jewelry

Drawing an item of love jewelry to your own specification is rather like drawing a mandala (*see page 104*): your serious purpose (in this case, a gesture of love) gives the design a powerful energy you can tap into in meditation. Let each stroke of your pencil be an expression of your love—for your partner, a family member or a friend. Use colored pencils to show different jewels. A pendant on a chain would be a good choice—not least because the chain would give you the opportunity to do some soothing rhythmic pattern work, and you could arrange it in an interesting formation around the pendant.

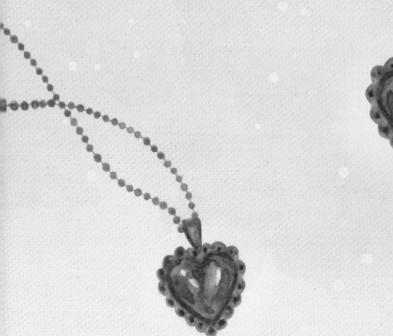

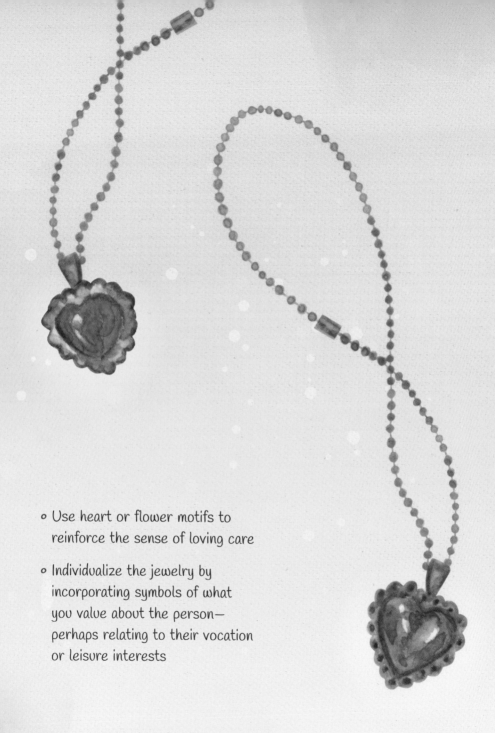

- Use heart or flower motifs to reinforce the sense of loving care

- Individualize the jewelry by incorporating symbols of what you value about the person— perhaps relating to their vocation or leisure interests

Drawing 30
Free pages—Family and friends

Use these pages to celebrate your connections with those dearest to you. Some possible approaches are:

○ A group portrait
○ A variety of talents and characteristics
○ A support network
○ A vacation together

6

Something to Celebrate

Cultivating gratitude

Mind-body-spirit thinking places great importance on the therapeutic effects of gratitude. A true appreciation of what we have, including what others give us, can be an effective measure against corrosive stress – and envy. Celebrate your own and others' successes, talents and positive choices, and extend your gratitude also to the wonders of the world around us, in nature, science and the arts. Drawing some of those blessings in a spirit of celebration can help us to be more balanced, happier human beings.

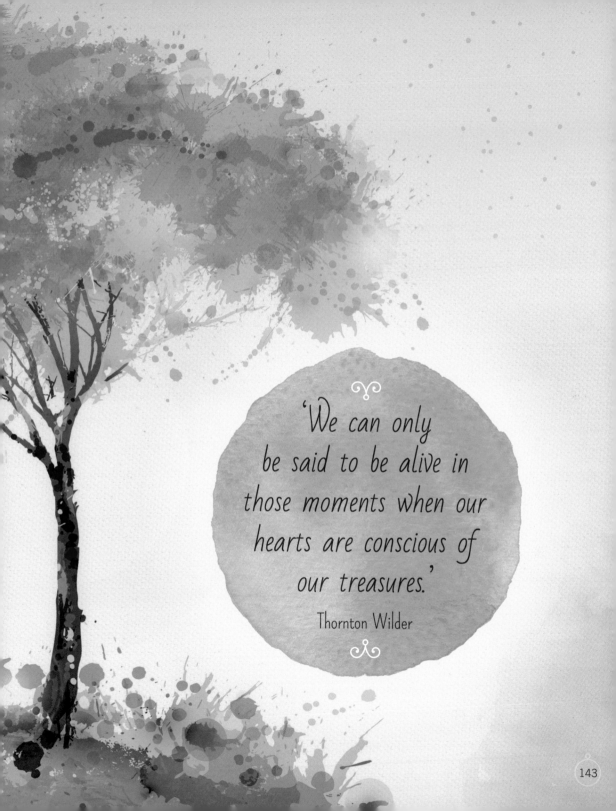

'We can only
be said to be alive in
those moments when our
hearts are conscious of
our treasures.'

Thornton Wilder

'When you arise
in the morning, think of
what a precious privilege it is
to be alive — to breathe, to
think, to enjoy, to love.'

Marcus Aurelius

Drawing 31

Beautiful morning!

This is a drawing to do before or just after breakfast. Think of it as a secular grace, a thanksgiving for life's everyday miracles — not least the rising sun. Draw whatever strikes you as being precious about the morning and the promise it holds. Include, if you like, good things you anticipate for the day ahead.

Some suggestions:

- Frame the drawing as the view through a window
- Include your breakfast in the foreground
- If there are other people in your home, depict them enjoying the start of the day
- Celebrate by including flowers

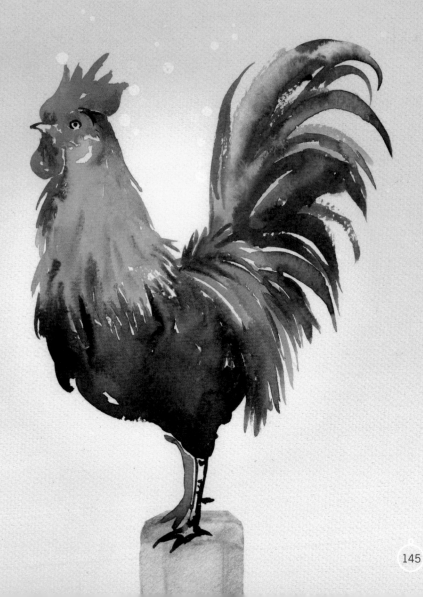

Drawing 32

A nature walk

Nature is an endlessly turning kaleidoscope, spinning off beauty in
countless ways every minute of the day. Draw the experience
of a soul-nourishing nature walk – whether remembered
or imagined. There's endless scope for creativity and
close observation – especially of foliage, flowers,
butterflies, birds and other wildlife.

Contemplation

In a spirit of relaxed meditation, project yourself imaginatively into your walk. Conjure up its sounds and smells, and the experience of walking and of touching what you see. Think of the place as out there, in reality, no less real than the room you're in now.

Drawing 33

A special day

Some days are days to 'mark with a white stone', as the saying goes. It's worth commemorating with a drawing any day when everything goes well or something special happens. Work from memory or from any photos you took. Include people who shared the experience with you – and put yourself perhaps, at the centre of things. If you wish, add a decorative border of flags. Use symbolism or realism, or a mixture of the two. If certain friends were unable to be present, put them in your drawing anyway – as compensation to them.

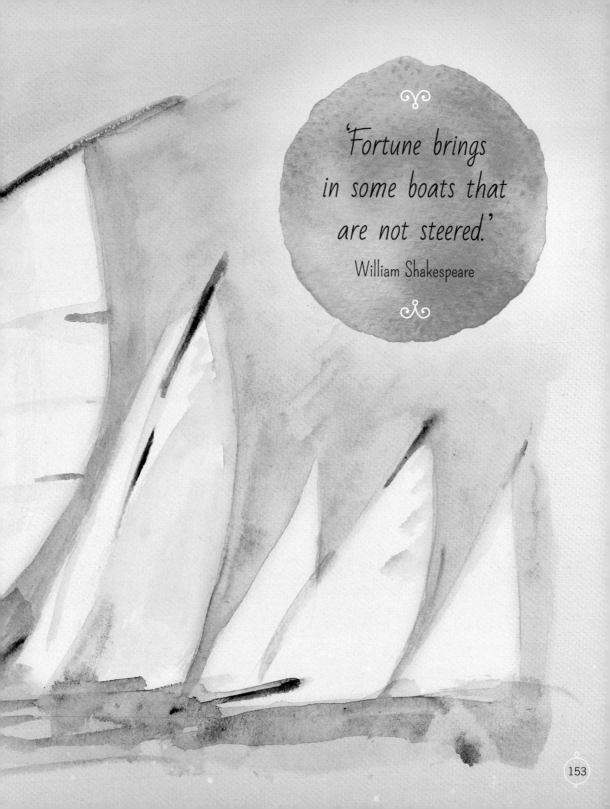

'Fortune brings
in some boats that
are not steered.'

William Shakespeare

Drawing 34

Free pages – Wow!

Use these pages to draw aspects of surprises and amazements in your life – keep adding, in different colours, to create a patchwork of celebration, like a quilt. In fact, if you wish, why not frame the drawing as a quilt, with one pleasant surprise per panel?

Some suggestions are:

- Reunion
- Declaration of love
- Beautiful weather
- Sighting of animal life
- Welcome gift
- Brilliant music
- Sporting triumph